MORE WONDERFUL YARD-LONG PRINTS

by

KEAGY & RHODEN

BOOK II — IN COLOR
AN ILLUSTRATED VALUE GUIDE

Photography by: Frank Miller, Linton, IN

Edited by: M. June Keagy & Joan M. Rhoden

Additional copies of this book may be ordered from the authors.

Mr. & Mrs. William D. Keagy
P.O. Box 106
Bloomfield, IN 47424

OR

Mr. & Mrs. Charles G. Rhoden
605 N. Main
Georgetown, IL 61846

QUANTITY DISCOUNTS-INQUIRE

ISBN 0 - 9633922 - 1 - 2

TABLE OF CONTENTS

THE KEAGY'S - Bill and June are both native Hoosiers, and have lived most of their lives in or near the Bloomfield, IN area.

They still love going to flea-markets, shops and shows when their schedules permit. Always on the lookout for another yard-long to bring home.

They will be retiring in 1993 and they hope to do more traveling and meet other yard-long collectors.

"Buttons" loves to go with them at all times, and is still a very good "traveler" at ten years of age.

THE RHODEN'S - Charles and Joan have been married forty years, with a family that consists of four sons, three daughters-in-law and nine grandchildren.

They have been collecting for the past twenty-five years. First was old Pattern Glass, then Heisey and many small collections in between. Last, but not least, came the yard-longs which have been a source of enjoyment for many years.

Their antique shop, "Memories," carries a full line of antiques and collectibles. They also have a book business that consists of most new books on antiques and collectibles that are in print today, sold by mail and in their shop. RETAIL and WHOLESALE.

Many people contributed in some way to make Book II a reality. To all of them, we owe a debt of gratitude.

A very special "thank you" goes to our photographer, Mr. Frank Miller, who went beyond the call of duty for us. When the prints could not be brought to his shop, he went to where the prints were for the photography session. In many cases, the prints could not be taken out of their frames, so he "shot" thru the glass. Without his expertise, Book II might well have remained just a dream.

We can't specify which contribution each of these wonderful people made, but each one listed below will know that we are forever grateful to each and everyone.

Roy and Joanne Sparks
Hal and Jean Wortham
Merl and Becky Strosnider
Steve and Jill Willard
Catherine Frazier
The late Vernon Carl Langlois
Mr. Alan DeLau
Mr. Richard Bright
Professor Jack Ford
Mr. Bill Martin
Mr. Robert E. Newnham

Bill and I want to thank our son Dennis, wife Shelia and the three grandsons, Shawn, Jayson and Jeremy for all their encouragement and help.

Since the First Edition came out three years ago, we have been in contact with hundreds of collectors who have shared information and/or comments. We will try to address some of them at this time.

For example; one gentleman pointed out that our book was not complete. We were very much aware of that fact, since our love was, (and still is) the lovely "Ladies." We aren't sure there will ever be a complete listing of all the Yard-Longs that were done. Every time we think we have knowledge of all prints, we get information about yet another one.

We know there are many flower and animal collectors out there that we neglected in the First Edition. To all of those collectors, we sincerely apologize and we hope Book II will meet with their approval.

Many people have commented that the only true Yard-Longs were the ones that actually were thirty-six inches in length and titled "A Yard of Puppies," "A Yard of Kittens," "A Yard of Roses," etc.

Over the years many more prints were accepted as a part of the Yard-Long category. Most collectors today feel that any print (whether horizontal or vertical) can be included in the category, if it is long one way and narrow the other. We know this will always be a matter of controversy, so we leave it to the collector to decide with their personal opinion.

In the late 1800's when many of these were done, they were known as Yard Pictures and advertised as such.

A very nice gentleman from Akron, OH sent us a zerox copy from a premium booklet that he had purchased concerning Walker's Family Soap, Pittsburgh, PA. They had nine Yard Pictures listed that could be had for twenty-five wrappers or

premium checks and two cents to pay postage. "Yard of Roses," "Yard of Puppies," "Yard of Violets," "Yard of Chrysanthemums," "Yard of Narcissus," "Yard of Tulips," "Yard of Pansies," "Yard of Pond Lilies," and "Yard of Kittens" were listed along with seventy-four other prints, various sizes, that could be had for twenty-five wrappers or premium checks and four cents to pay postage.

There have always been buyer incentives as far back as anyone can remember, and we are sure that if anyone cares to delve into this bit of trivia, it probably would go back to the Stone Age.

Our very collectable Depression Glass was found in boxes of oats, etc., or you may have opened a box of laundry powder to find a towel, dish towel or a nice wash cloth which could be used or put away for someone's hope chest.

Just as we have coupons, discounts and rebates in this decade, buyer incentives have always been one of the most successful of the marketing tools that were used over the years.

Before the turn of the century when many of the animal and flower prints were done, the litho companies made these for wholesale distribution to the various individual companies to use as premiums when their product was bought by the consumer. When they found a print that seemed to be very popular with the public, that particular print may have been done by several different litho companies, as we can verify with "Yard of Puppies" print shown on page fifty of the First Edition. We have found this same print with three different dates and done by three different lithograph companies. The earliest date we have found is 1896, another for 1903, and yet another for 1906, so, it wouldn't be surprising to find other companies and dates,

as well.

Many of the companies had the lithographs made specifically for their products, such as; Pabst with their Malt Extract advertising, Pompeian with their cosmetics advertising and a host of others. Some others were The Great Atlantic & Pacific Tea Company, Mandeville & King Seedsmen, The Diamond Crystal Salt Co.; shoe companies such as Selz Good Shoes and Walk-Over. Many of the family magazines, such as; American Farming, The National Stockman & Farmer, The Youth's Companion and many others found these prints to be a great incentive for new subscribers. We may never know how many different companies used these beautiful lithographs as an advertising medium.

It still amazes us that so many of these have survived over these many years. The earliest one that we can verify is dated 1891. We are thankful for all the people who never threw anything away and gave us a chance to enjoy these beautiful old lithographs during our lifetime.

We all know that many of these great old prints were trimmed in some way, either to fit an existing frame or because they did not want the advertising to show. No one, at that time, could have foreseen the collectability of these prints or how much it would affect their value when they had been trimmed. All they wanted was something pretty to decorate their home. In that time period, (in some cases) these may have been the only decorative pieces of art that they could afford. Even the few cents cost, may have seemed like a lot of money in those days. We can safely assume that is why it was called "poor-man's art."

As we are all aware, any kind of damage, whether it be

stains, tears, holes or being glued to the backboard as well as being trimmed in any way will always reduce the monetary value. Most advanced collectors will not want a print with any major damage, even if the cost is minimal. There might be one exception; if the print is very rare and the chances of finding one in mint condition would be next to impossible.

At this time we want to reiterate; if you are fortunate enough to find one of these wonderful old prints in mint, or near mint condition, please, do not trim anything from it.

As with the Pabst, most (possibly all) originally had cardboard rolls at the bottom of the print, which served as an anchor when it was hung on a wall. Unfortunately, most times, these were cut off so they could be easily framed. As in the case of the one shown on page twenty-one of the First Edition, the roll was gone when we acquired it and that was where the date was. We later found one in mint condition, with roll intact, so we can now verify it to be a Pabst, dated 1911.

We saw one framed with the roll intact, so we know it is possible to save all of these in their original state. The inside of the wooden frame had been built up about an inch, which made a space between the glass and the backboard to accomodate the cardboard roll. Any good frame shop could do this, we're sure, or if you have a handy-man husband, maybe he could be persuaded to try his hand at it!

If you want to preserve these beautiful old lithographs, please do them a favor and replace the old cardboard backing (in some cases, even wood) with the new acid-free type that is available at most frame shops. There is also an acid-free matting, which would also be of help in preserving the prints.

The Selz print on page forty-six of the First Edition can now

be verified as a 1919. The unknown one on page ninety-three is also a Selz, dated 1920.

For Book II, we have tried our utmost to furnish all information available for each print shown, but there was many of these that could not be taken out of their frames for the photography, therefore, any information on the margins was not available to us. We apologize for this, but we thought the photographs would be appreciated even without the information. We hope the old adage "one picture is worth a thousand words" will be sufficient for an explanation.

As always, we welcome all comments and information that anyone wants to share. Please enclose SASE if you would like a response.

All of the information in this article comes from a wonderful little thirty page booklet entitled "The Stone Age of Printing" done by Mr. Bill Martin (retired printer) of Oakville, Missouri. It was made available to us through the courtesy of Professor Jack Ford who teaches Stone Lithography at California College of Arts and Crafts, in Oakland, California.

We enjoyed it very much, and with Mr. Martin's permission, we decided to use part of it for Book II. Hopefully some of our readers will enjoy it, also.

Lithography was invented in 1798 by Alois Senefelder (1771-1834) who was born in Prague, then belonging to Austria, as the son of a German actor.

Although, during his lifetime, he was engaged in various business enterprises, lithography was always his great love. He made many improvements in the lithographic process and was rewarded with valuable presents, prizes, as well as medals. After a very full and active life, he died at the age of sixty-three.

Lithography was not very popular in its early stages. It was a very tedious, time consuming process, as every step had to be done manually. Only the most dedicated would pursue it as a lifelong career.

It didn't come to the shores of America until 1818. The first lithograph to be published in the United States was of a beautiful estate on the water done by Bass Otis, and appeared in The Analectic Magazine of August, 1819.

The publication of Bass Otis' lithograph did not lead to an immediate spreading of lithography in the United States. Only a handful of people were active in this field during the twenties and thirties of the nineteenth century. Barnett and

Doolittle opened shop in New York in 1821 and became the first lithographers in the United States. Two brothers, William S. and John B. Pendleton are known as the most important early American lithographers. William S. Pendleton, together with Abel Bowen, started the first lithographic business in Boston in 1825. His brother John B. Pendleton, together with Francis Keary and Cephas G. Childs became the first Philadelphian lithographers in 1829 or 1830.

In 1835, Duval produced the first American color lithograph "Grandpapa's Pet," drawn and lithotinted by John R. Richards. It was done expressly for Miss Leslie's Magazine.

The real spread and growth of lithography in the United States did not set in before the forties of the nineteenth century. In the following decade chromolithography, the making of lithographic prints in many colors, became established. In these chromos, stone lithography reached it's highest and in a sense, final form. The next great changes, modern lithography (without stone) was created just before the turn of the century.

In nearly a century and a half, commercial lithography has made extraordinary technical advances. Photographic methods, halftone screens, metal plates, offset presses and other developments have revolutionized lithography, without however, altering the basic principles discovered by Senefelder.

The products of commercial lithography were highly diversified. Some of these were maps, sheet music, magazine covers, advertisements, business stationary and checks, not to forget the beautifully calligraphed stock and bond certificates or life insurance policies.

In 1850 the United States was very small (a little over

twenty-three million) and the majority of the people lived outside the cities, which were also much smaller than our cities of today. The prints done in this era gave the people a chance to participate in politics, the exploration of their country, great and not so great political events, the achievements of science and technology just by looking at lithographic prints depicting the contemporary scene.

Currier and Ives are probably the most notable lithographic print-makers, although there were many others who should be remembered, also.

Around the turn of the century, when many of the Yard-Longs were done, one may come across such names as Forbes, J. Ottmann, Jos. Hoover & Son, The Art Interchange Co., The Osborne Co., Perry Mason & Co., Brett Litho Co., The Gray Litho Co., and Brown & Bigelow, as well as a host of others.

We would like to thank everyone who contributed to the making of the prints that are so collectable today. Even with all the technology available today, the laser prints of this era just cannot be compared to the prints done around the turn of the century.

If anyone would like to know more about the Stone Lithography, there are many good books at your local library. It is a fascinating subject.

Since the First Edition came out we have learned a lot about the reproductions. The first thing we became aware of is that we may not necessarily want them in our collections, but there is a definite need for them in some cases. Consider the young people just starting out, they may want some beautiful prints, but can't afford the old lithographs just yet. Most of the reproductions that we have come across are very beautiful, and are very affordable even if you are on a limited budget.

We see the need, but our concerns are about the small percentage of "not very nice people" who may be tempted to sell the reproductions as being old.

Just be aware that reproductions are a fact of life, know that there are some who will swear that it "came from Grandma's attic", just to make a sale. Learn as much as you possibly can about your area of collecting, whether it be the old prints or something entirely different. There are reproductions for everything that has become collectable.

In this value guide, any print that has been reproduced to our knowledge will be marked. At the end of the information for the print, it will be marked in the following manner. (R)

Others we don't show are; "Pennsylvania Shortline" or "Sunbonnet Babies," the 1907 and the 1914 Pabst Extract, also the 1927 Pompeian "Bride" by Rolf Armstrong.

There are many ways to identify the reproductions; first and foremost, the paper is much different in weight and color. There may be one bright spot; the ones that originally had advertising on the back have not been reproduced on the backs (therefore, the backs are plain.) The new prints will also have the new litho date and company name on the margin, unless it has been trimmed off.

We want to reiterate; we do not have any conflict with the reproductions as long as they are REPRESENTED AND SOLD AS REPRODUCTION PRINTS.

Just be aware that they are a part of collecting; and knowledge is always the best defense when buying and/or selling.

We stress the fact that most reputable dealers would be only too happy to let you "undress it" and ascertain that it is an old print to your satisfaction.

KNOW YOUR DEALER

The values given for the lithographs shown in this illustrated guide are not meant to set prices on the open market.

Values will vary greatly from one area of the country to another. Many things may affect the prices realized; such as availability, condition, demand for the item and a host of other things. The bottom line is the collector, and how much they are willing to pay.

The values are based on "very good" to "excellent" condition. Our interpretation is as follows; full length, in original frame with no other major damage, such as creasing, tears, holes, or being glued to the backboard. ANY OR ALL OF THESE CONDITIONS WOULD GREATLY REDUCE THE VALUE.

We cannot assume any responsibility for any monetary loss or gain from the buying or selling of any of these prints, now or in the future.

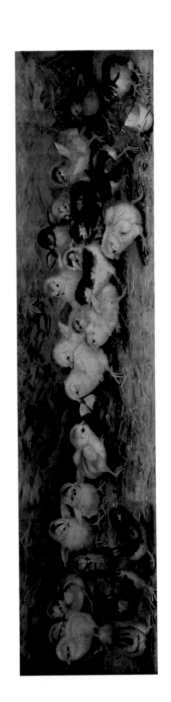

"Battle of the Chicks" by Ben Austrian. Copyright 1920 by The Art Interchange Co. of New York.

$100-$150

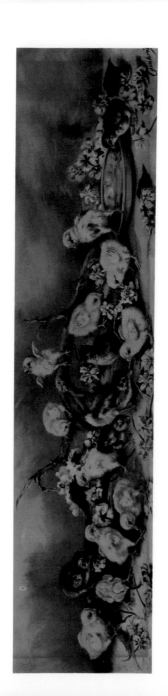

"Spring is Here" by Cambril. Copyright 1907 by The Gray Litho. Co. of New York.

$100-$150

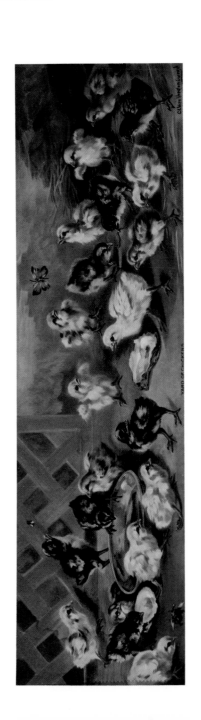

"Yard of Chickens" by C. L. VanVredenburgh. Copyright 1905 by J. Ottmann Lith. Co., N.Y. (R) $100-$150

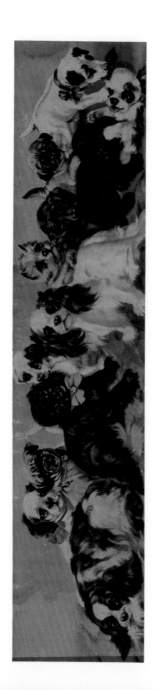

Yard of Dogs by C. L. VanVredenburgh. No other information available. (R)

$100-$150

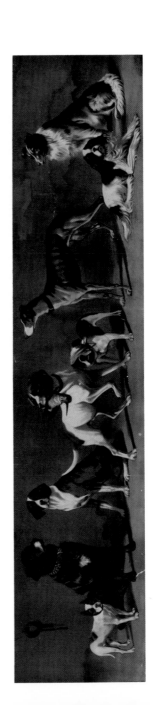

Yard of Dogs. Copyright 1903. No other information available.
$125–$175

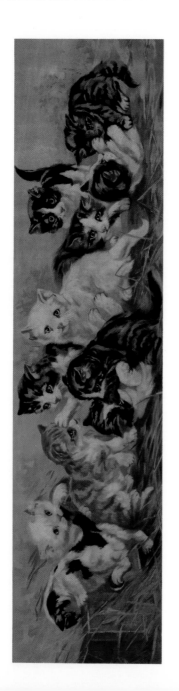

"Yard of Kittens." This print and the one on the following page are interesting in the fact that they seem to be identical-except that the boxes are on opposite ends of the prints!! (Box on left)

$100-$150

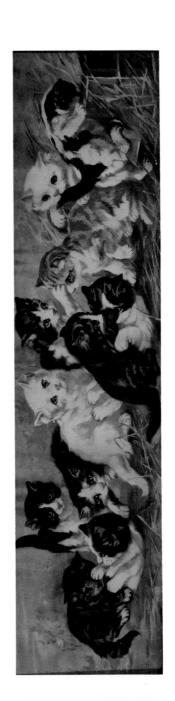

Same print as preceding page with the box on the right. We have no explanation for this, maybe some of our readers know? No other information available to us. $100-$150

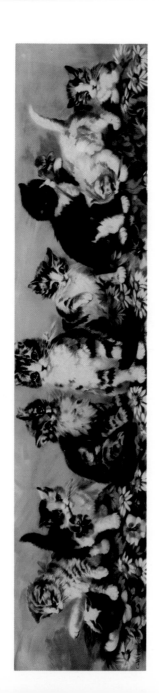

"Yard of Kittens" by C. L. Van Vredenburgh. No other information available. (R)
$100-$150

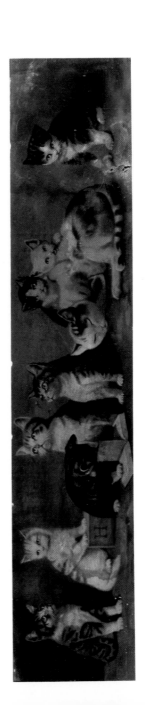

Kittens with mother. No other information available. $125-$175

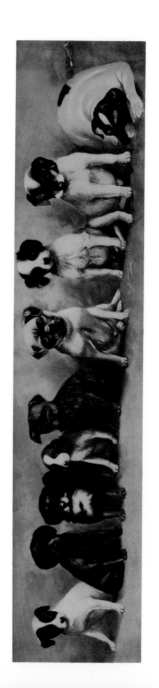

Yard of Puppies by Guy Bedford, Chicago. No other information available.

$125-$175

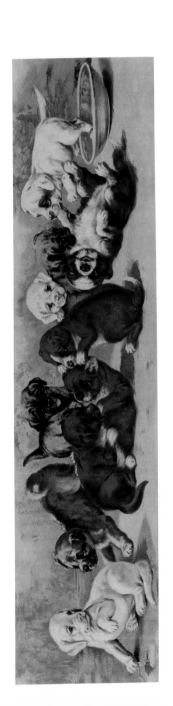

"Yard of Puppies." Copyright 1896, and published by P. O. Vick-ery, Augusta, Me. No other information available. $100-$150

"Tug of War." No other information available. (R)

$100-$150

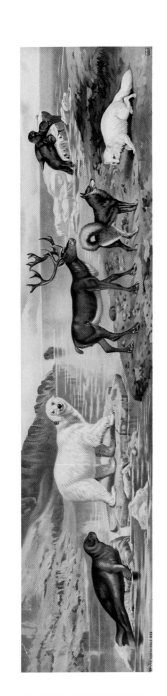

"At the North Pole." Copyright 1904 by Jos. Hoover & Son, Philadelphia.
$200-$250

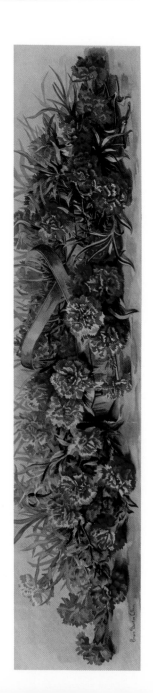

Carnations by Grace Barton Allen. No other information available.
$80-$130

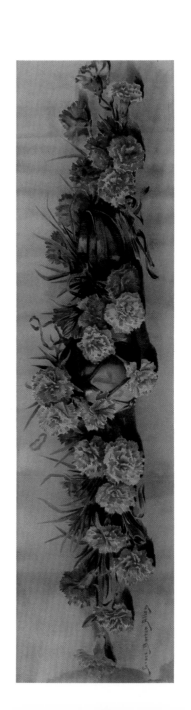

Carnations by Grace Barton Allen. No other information available. $80-$130

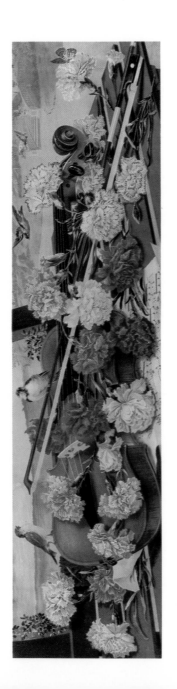

"Carnation Symphony." No other information available. $90-$140

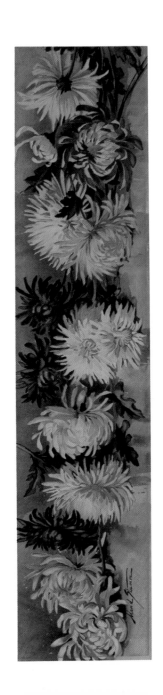

"A Yard of Chrysanthemums" by Maud Stumm. No other information available.

$80-$130

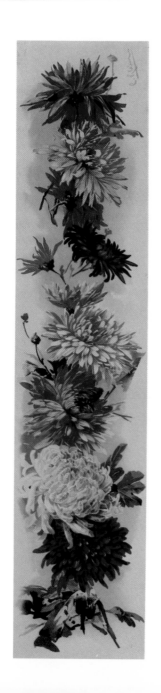

Chrysanthemums by C. Klein. No other information available.
$80- $130

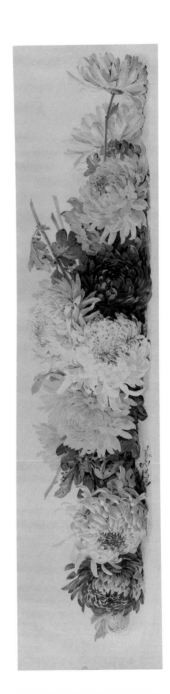

"Study of Chrysanthemums" by Paul DeLongpre. Copyright 1900 by The Art Interchange Co., N.Y. by Brett Litho. Co., N.Y.

$100-$150

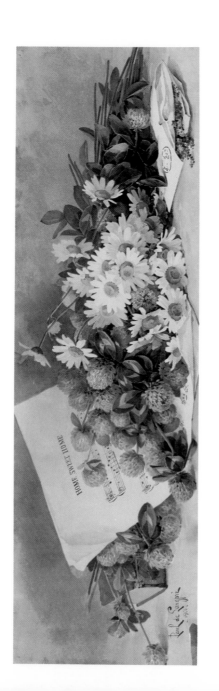

"Home, Sweet Home" by Paul DeLongpre. Dated 1901. $100-$150

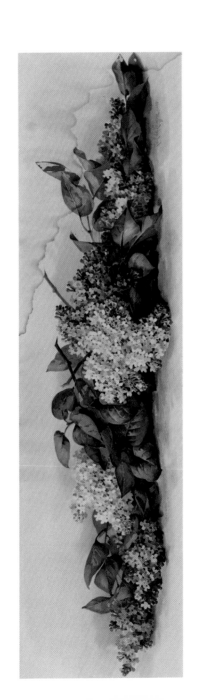

"White and Purple Lilacs" by Paul DeLongpre, 1896. Copyright 1897 by The Knapp Co., N.Y.
$100-$150

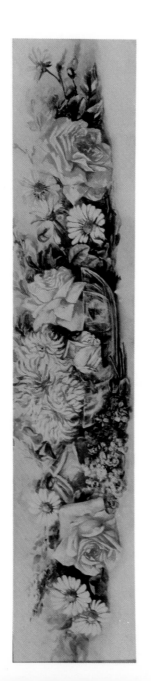

"A Yard of Mixed Flowers" by Guy Bedford. No other information available.

$90-$140

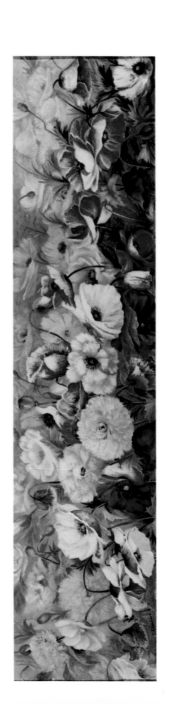

Mixed flowers by S. Clarkson. Copyright 1892 by J. F. Ingalls, supplement to Ingalls' Home and Art Magazine, December 1892 by Armstrong & Co..

$80-$130

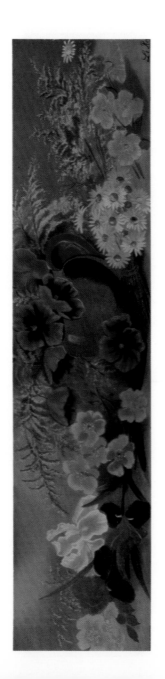

Mixed flowers by LeRoy. No other information available. $90-$140

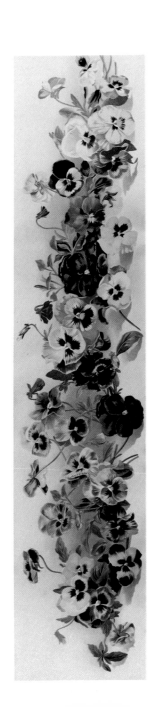

"A Shower of Pansies" by Muller Luchsinge & Co., N.Y. Copyright 1895. $80-$130

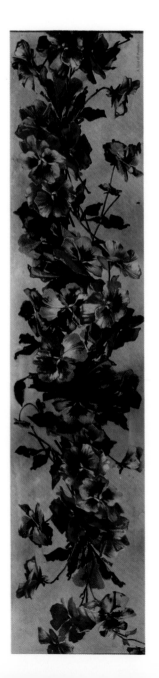

"A Yard of Pansies" in lower right corner. No other information available.

$80-$130

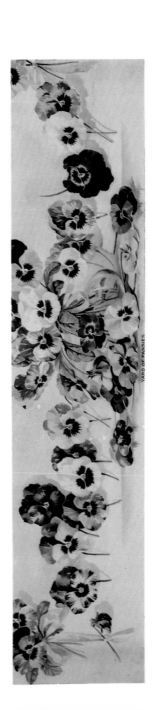

"Yard of Pansies" by Heinmuller. No other information available.
$85-$135

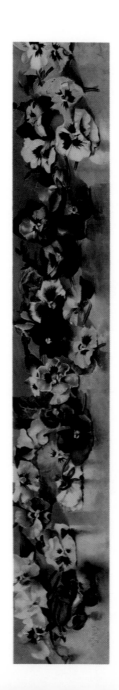

Yard of Pansies by V. Janus. Done by G. H. Buer & Co. Lith, N.Y.
$80-$130

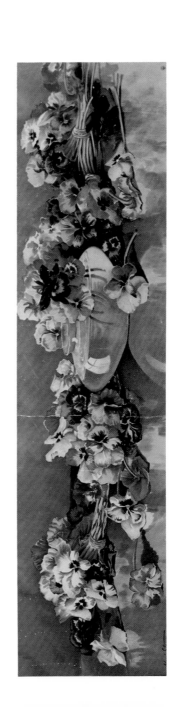

Yard of Pansies by Maud Stumm. No other information available.
$80-$130

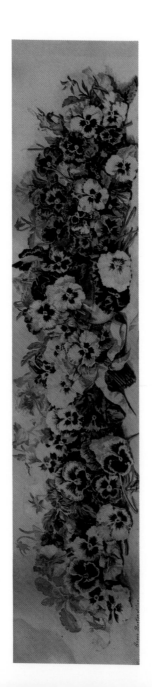

Yard of Pansies by Grace Barton Allen. No other information available.
$80-$130

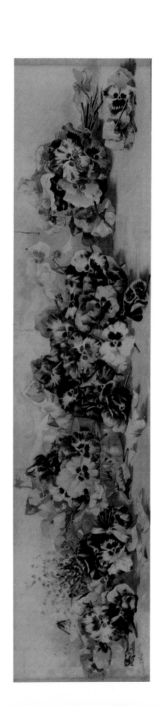

Yard of Pansies by Henrietta D. LaPrank. No other information available. $80-$130

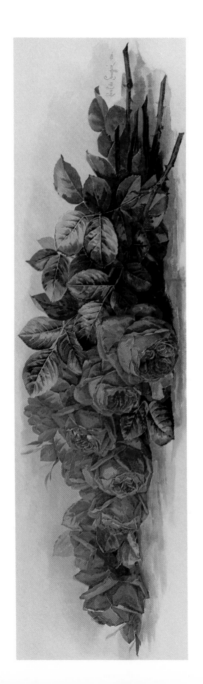

"American Beauty Roses" by Paul DeLongpre. Copyright
1896 by The Art Interchange Co. of New York.(R) $100-$150

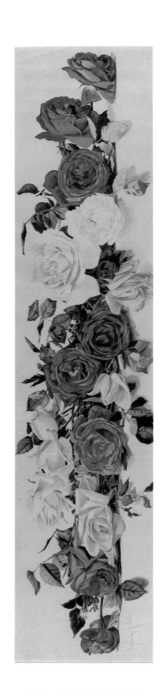

"A Yard of Roses" by Newton A. Wells. Copyright 1898. $90-$140

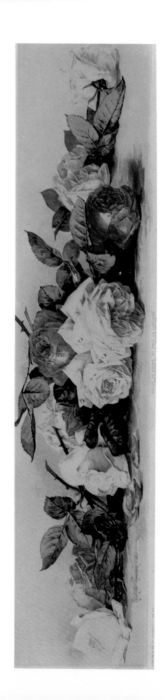

"Study of Roses" by Paul DeLongpre. Copyright 1895 by The Art Interchange Co. of N.Y.
$100-$150

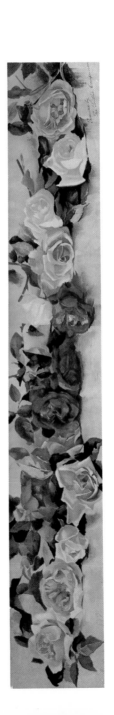

Yard of Roses by V. Janus. Copyright 1891 by Perry Mason & Co..
Presented by The Youth's Companion.
$90-$140

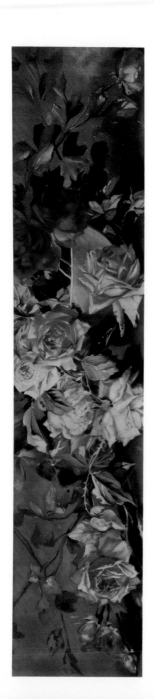

"Yard of Roses." No other information available.

$75-$125

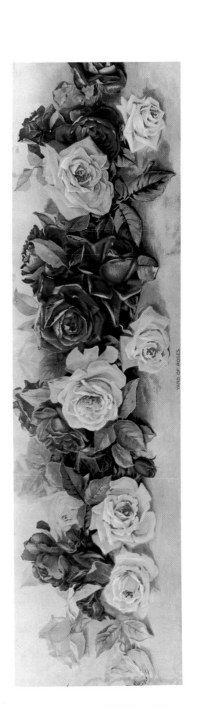

Yard of Roses. Copyright 1901 by J. Ottmann Lithograph Co., N.Y.
$100-$150

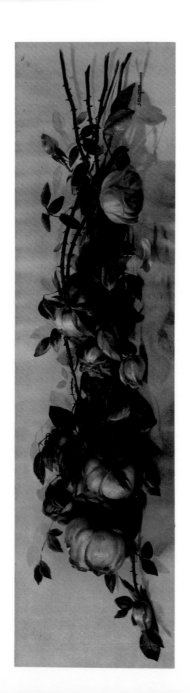

"The Pride of America" by J. Califano. No other information available.

$85-$135

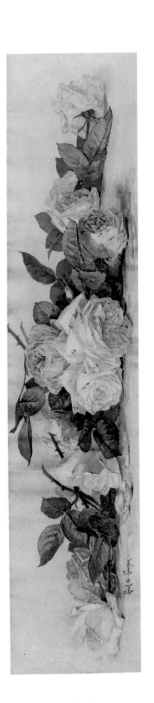

White Roses by Paul DeLongpre. No other information available.
$100-$150

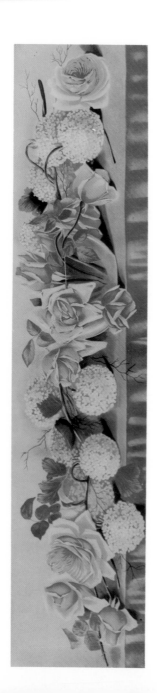

Roses and Snowballs. No other information available.

$75-$125

"American Beauty Roses" by Newton A. Wells, 1894. Copyright 1895 by The Art Interchange Co., N.Y. $90-$140

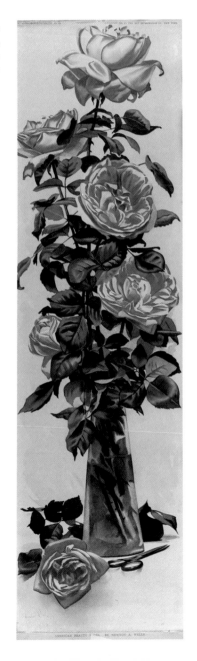

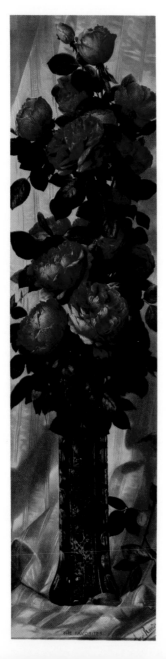

"The Favorites" American Beauty roses by A. Romes. No other information available.

$100-$150

Vertical Roses by The Great
Atlantic & Pacific Tea Co., N.J.
Signed Damgam? $100-$150

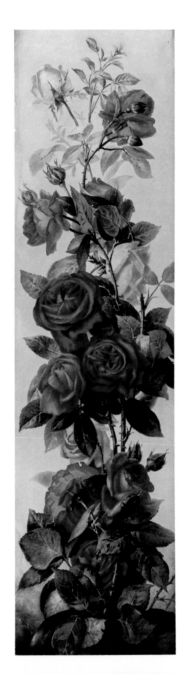

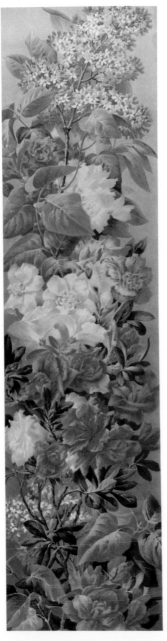

Vertical Roses and Lilacs. No other information available.
$75-$125

Nasturtiums painted for Mandeville & King, Seedsmen, Rochester, N.Y. $100-$150

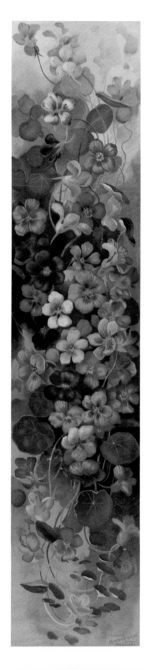

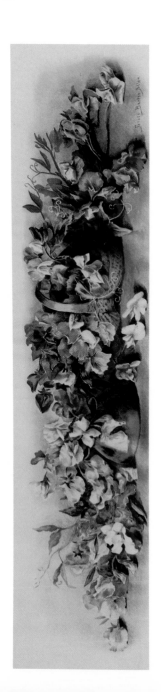

"Study of Sweet Peas" by Grace Barton Allen. Copyright 1900 by
The Art Interchange Co. of New York.

$100-$150

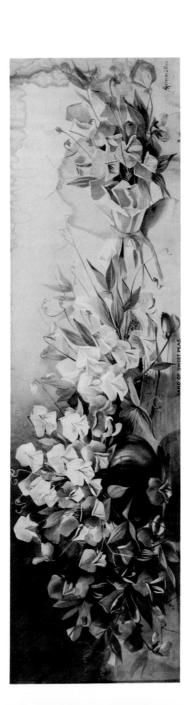

"Yard of Sweet Peas" by Heinmuller. Copyright 1905 by J. Ottmann Litho Co., N.Y.

$90-$140

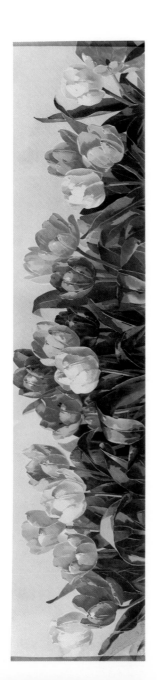

Yard of Tulips by Paul DeLongpre. No other information available.
$125-$175

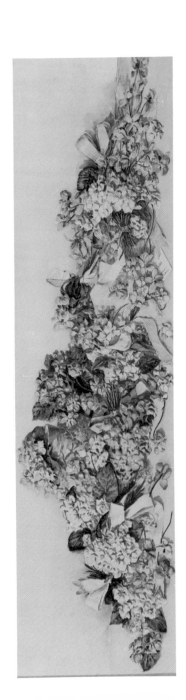

"Bridal Favors" by Mary E. Hart. No other information available. $100-$150

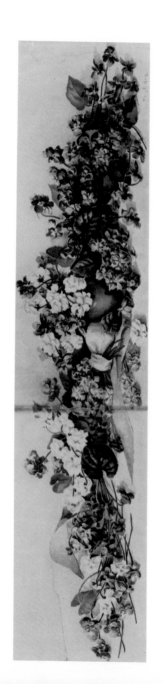

"A Study of Violets" by Mary E. Hart. Copyright 1900 by The Art Interchange Co., N.Y.
$100-$150

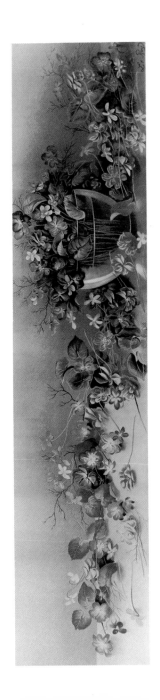

$90-$140

Yard of Violets in crystal bowl. Signed LeRoy.

Water Lilies with dragonfly by Fisher. No other information available.
$90-$140

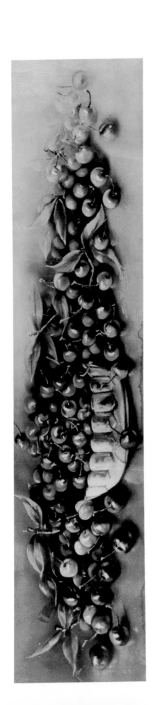

"A Yard of Cherries" by Guy Bedford. Copyright 1906 by The James Lee Co., Chicago.

$100-$150

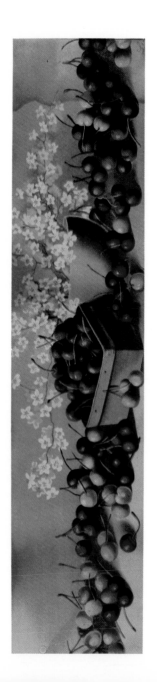

Yard of cherries and flowers by LeRoy. No other information available.

$100-$150

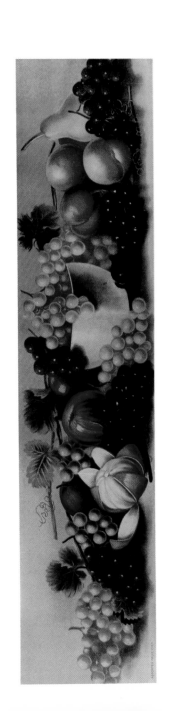

"Assorted Fruit." Copyright 1897 by Jos, Hoover & Son, Philadelphia. No other information available. $100-$150

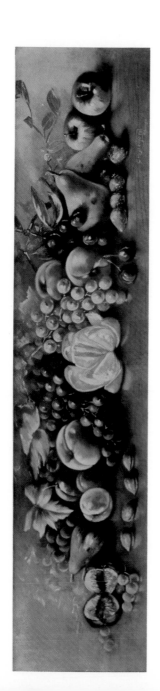

Yard of assorted fruit by Guy Bedford, Chicago. No other information available.

$100-$150

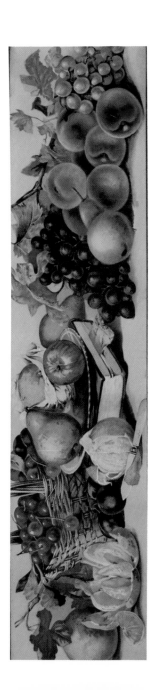

Yard of assorted fruit. No other information available. $100-$150

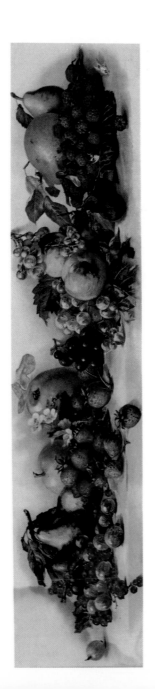

Yard of assorted fruit. No other information available. $100-$150

This is reported to be a 1914 Cosmopolitan lady, signed Gregson, N.Y. We can't verify if it was done by them or just advertised by them. Any ideas?

$150-$200

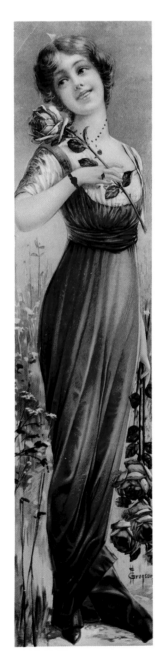

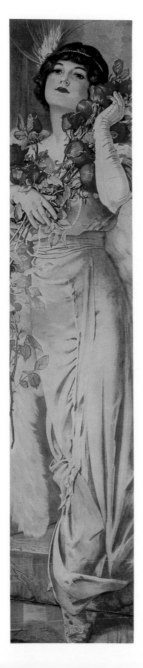

Pompeian ? No other information available. (R) $150-$200

Pompeian ? No other information available. (R) $150-$200

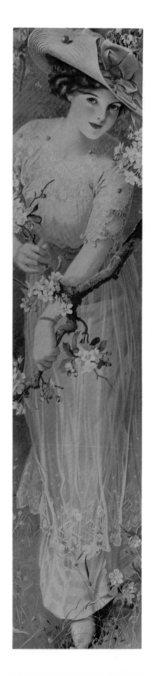

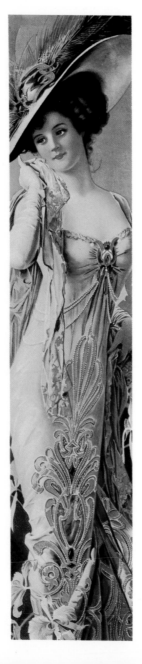

1911 "Pompeian Beauty" by Forbes. Calendar and advertising on back. (R)　　$200-$250

1913 "Pompeian Beauty" art panel. Advertising and calendar on back. $175-$225

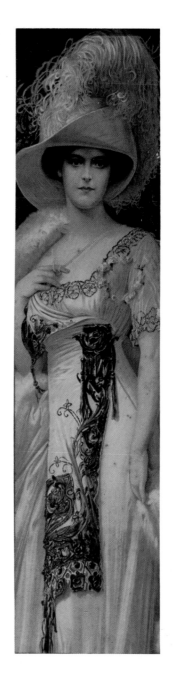

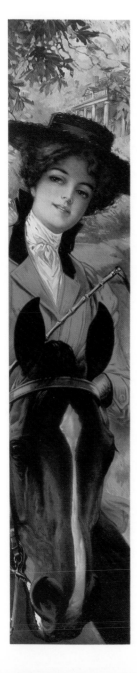

1912 Pabst Extract "American Girl" calendar. Copyright 1911 by C. W. Henning. Signed with calendar and advertising on back. (R) $175-$225

1911 Pabst Extract "American Girl" calendar. Copyright 1910 by C. W. Henning. Note: This example is full length with cardboard roll at the bottom intact, as well as a re-order form still attached at the top.
$200-$250

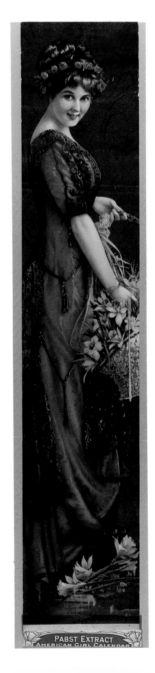

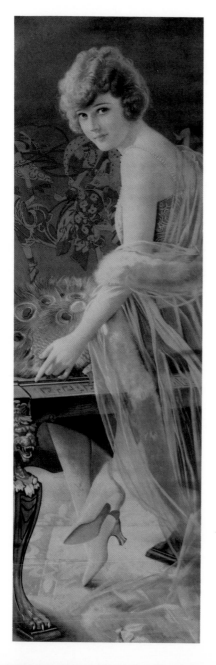

Selz Good Shoes ? No other information available. $150-$200

1918 Selz Good Shoes. Copyright Selz, Schwab & Co.. Calendar and advertising for Hughes Clothing Company, (Dependable Clothes Merchants) of Sabetha, Kansas. These were "made to order calendars" and may be found with many different business advertisements.

$200-$250

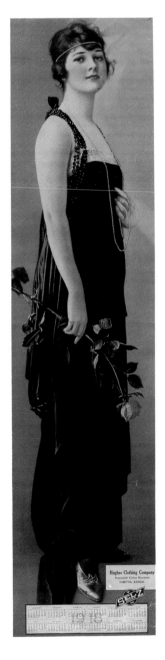

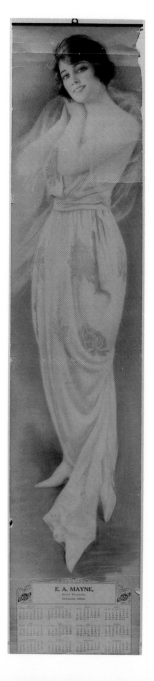

1920 Selz Good Shoes. Signed Haskell Coffin. Calendar with advertising for E. A. Mayne, General Merchandise, Sanborn, Iowa. $175-$225

1929 Selz Good Shoes. Signed Earl Chambers. Advertising for Hughes Clothing Co. (Dependable Clothes) of Sabetha, Kansas. $150-$200

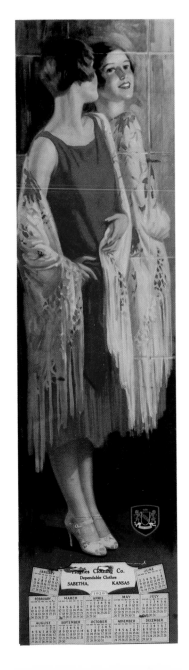

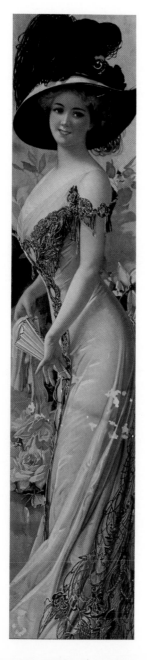

Lovely lady for the Marietta Stanley Company. Listing of their products on the back of the print. There is also a bookmark with the same lady and information. We cannot verify a date. $175-$225

Could she be a Selz ? No other
information available. $150-$200

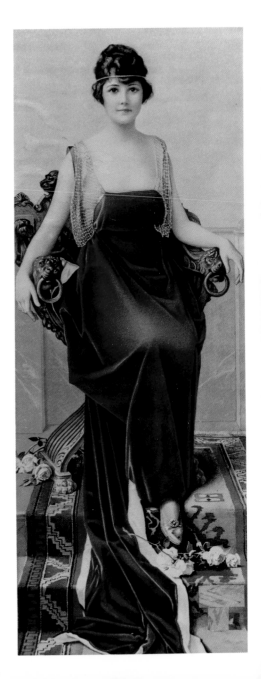

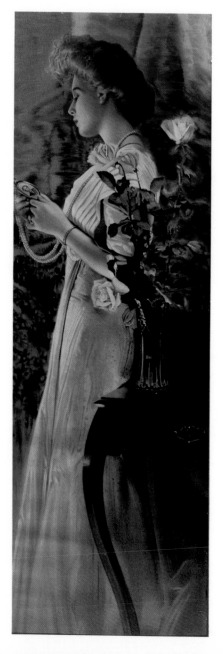

Compliments of D. A. Clark, Colfax, Ill. stamped on the back of the print. According to information received from the Historical Society of McLean County, D.A. Clark was a men's fashion and dry goods store. They were in business from 1893 to approximately 1916. No other information available to us. $125-$175

No information available for
this lovely lady.　　$130-$180

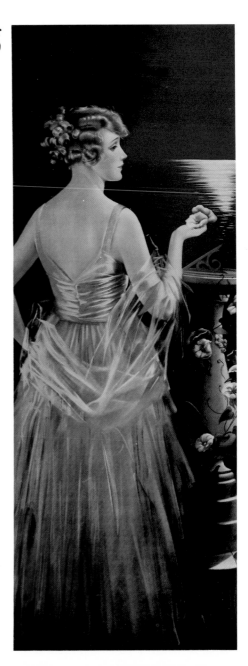

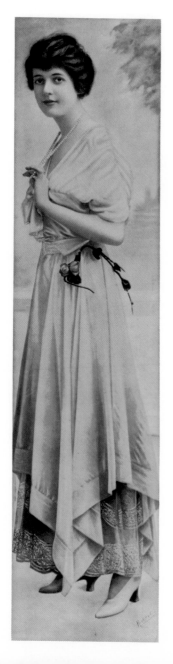

1917 calendar on back. Signed Hinkston. No other information available. $135-$185

1916 Signed H. Dirch. "The Clay, Robinson & Co. Army Of Employees" shown on back.

$145-$195

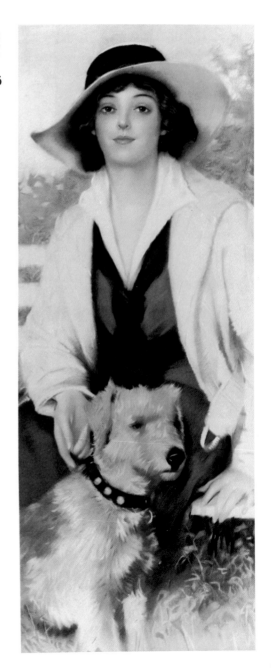

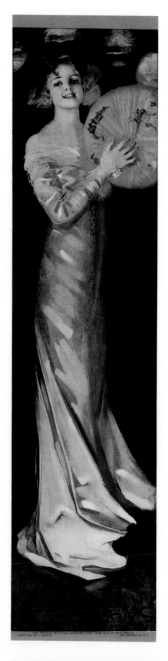

"The Girl with the Laughing Eyes." Copyright 1910 by F. Carlyle. Done by The Osborne Co., N.Y. $140-$190

"Barbara" 1912 Signed C. Allan Gilbert by Brown & Bigelowe, St. Paul, USA and Sault Ste. Marie, Ont. $135-$185

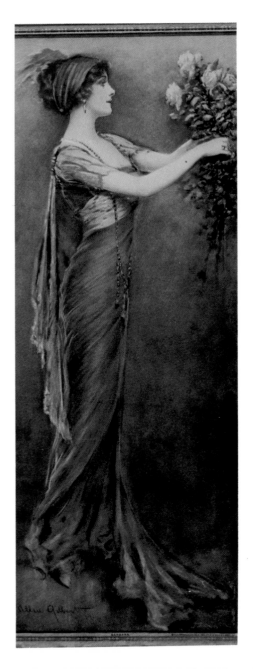

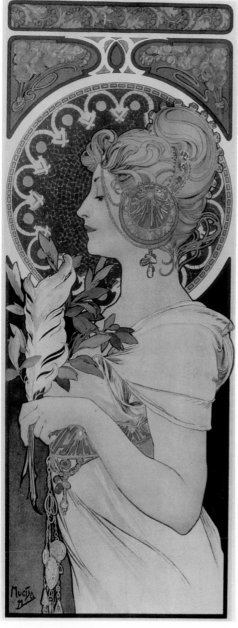

The lithographs shown on the next five pages will be just a few of the many beautiful Art Nouveau type prints that were done by Alphonse Mucha around the turn of the century.

Any collector should be proud if they are fortunate enough to have any of his work in their collections.

We can't verify any sales on the open market, so we have nothing to compare them with to set any kind of values.

These will all be signed Mucha and dated.

Mucha print signed and dated.

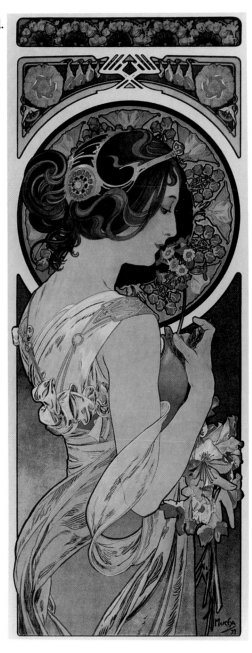

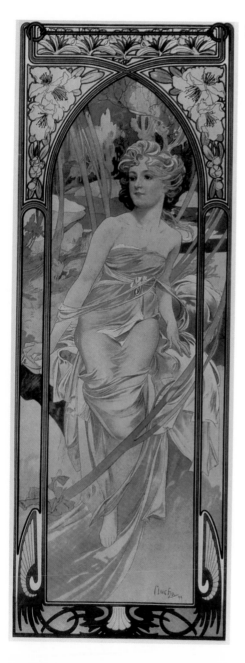

Mucha print signed and dated.

Mucha print signed and dated.

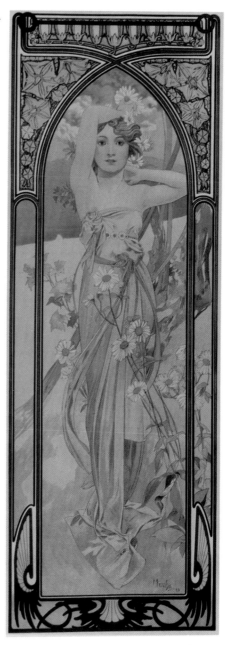

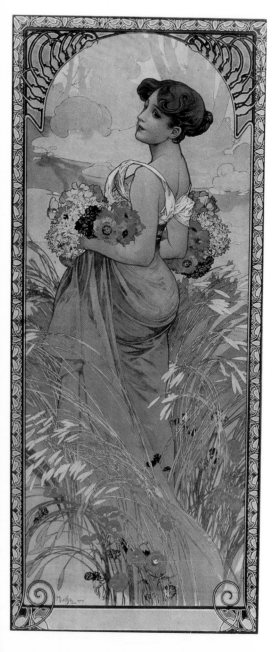

Mucha print signed and dated.

1928 or 1929 ? Pompeian Art Panel "Alluring." Signed Bradshaw Krandall. Advertising on back for their products.
$135- $185

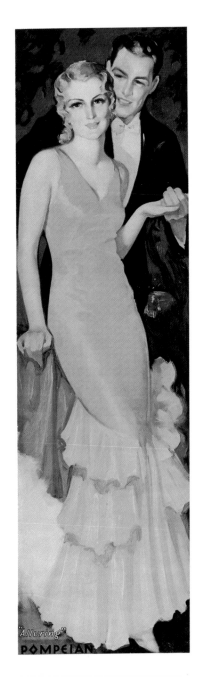

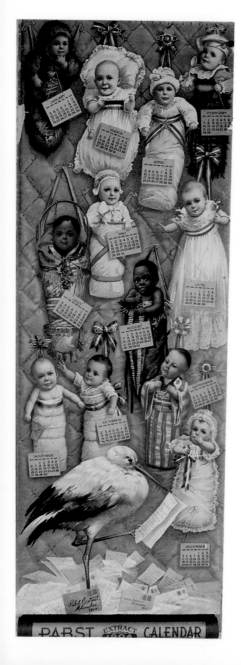

1904 Pabst Extract. Copyright 1903. Advertising and information on back. A different nationality baby for each month of the calendar on front, plus the original cardboard roll at the bottom. $200-$250

1906 Pabst Extract Indian Cal-
endar. Copyright 1905 by C. W.
Henning. Back of print has
poem, "Hiawatha's Wooing"
with picture of Minnehaha. This
one shows metal hanger at top
and cardboard roll at bottom.
$250-$300

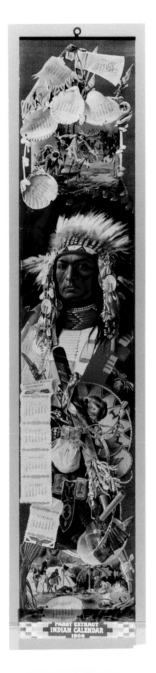

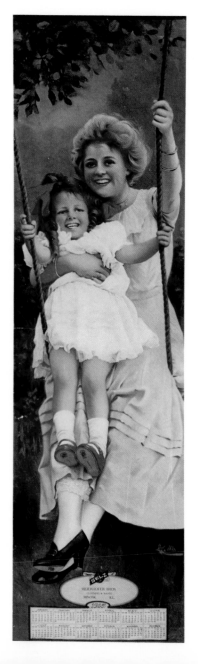

1915 Selz Good Shoes. Signed but can't decipher the signature. Advertising for Meierhofer Bros. Clothing & Shoes, Minonk, Ill. $150-$200

Signed W. Grayville Smith.
Copyright 1892 by Wood &
Parker Litho Co., 5th Ave., N.Y.
for Godey Publishing Co.

$125- $175

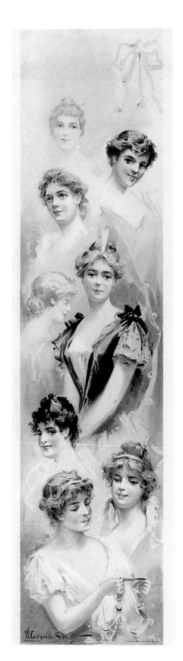

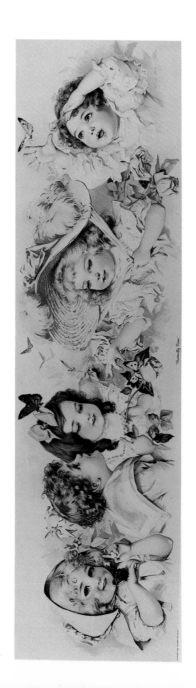

1903 "Butterfly Time" by Maud Humphrey. Signed Maud Humph-
rey. Copyright 1903 by The Gray Litho Co., N.Y. $200-$250

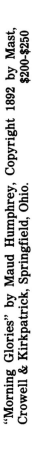

"Morning Glories" by Maud Humphrey, Copyright 1892 by Mast, Crowell & Kirkpatrick, Springfield, Ohio. $200-$250

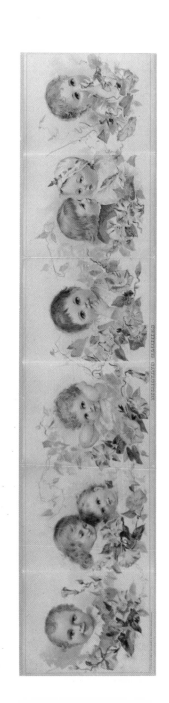

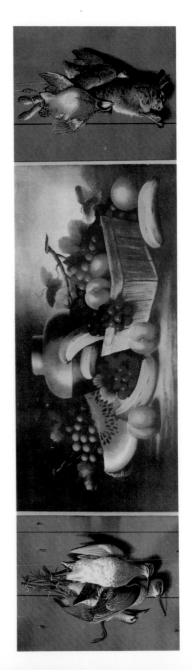

Montage of three game birds, assorted fruit and rabbit with two quail. No other information available. $75-$125

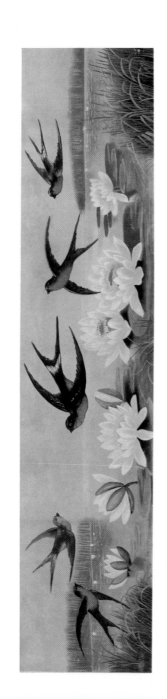

Swallows over Lillypads. Copyright 1897 by J. Hoover & Son, Philadelphia.
$150-$200

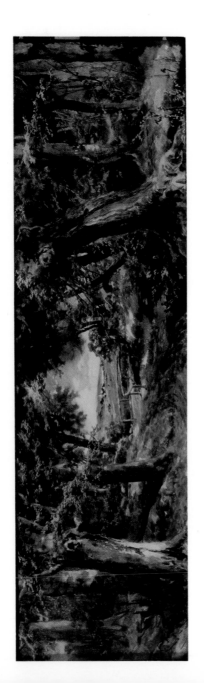

Beautiful woodland scene. No other information available. $75-$125

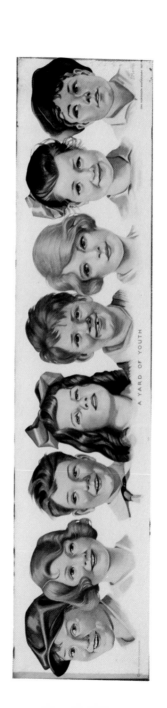

"Yard Of Youth" by F. L. Martini. Presented by The Youth's Companion for their 100th anniversary. (1827-1927) $150-$200

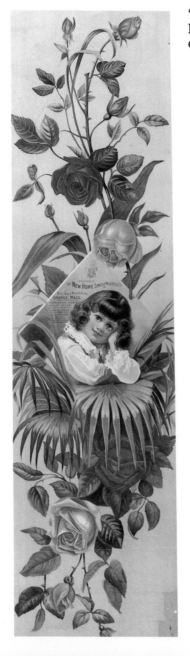

"Compliments of the New Home Sewing Machine Co.". No other information available.
$190-$240

1915 Pompeian Beauty Calendar. "The Witching Hour" by F. Earle Christy. This is exactly like the bigger Yard-Long, except that it measures a neat little four and half inches by eighteen and a half inches. We know of at least three others this size, so there are possibly more of them. We understand these were known as "Half-Yards." $50-$75

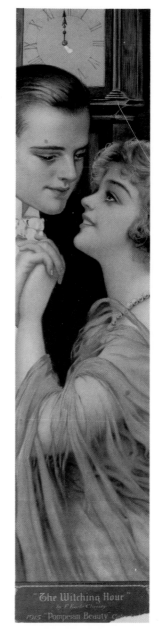

This is another example of the Half-Yards. No other information available. $50-$75

Pabst Malt Extract "Calendar of Old Japan" for 1903. It measures eight inches by thirty-seven inches and could be had for six cents in stamps. Advertised in The National Magazine. $15-$20

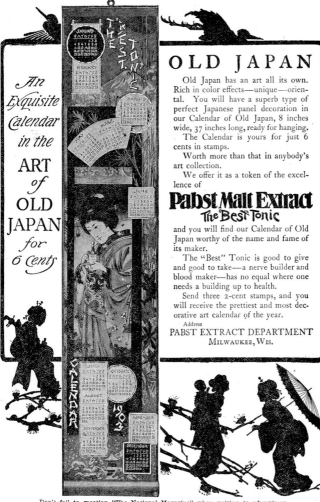

An Exquisite Calendar in the ART of OLD JAPAN for 6 Cents

OLD JAPAN

Old Japan has an art all its own. Rich in color effects—unique—oriental. You will have a superb type of perfect Japanese panel decoration in our Calendar of Old Japan, 8 inches wide, 37 inches long, ready for hanging.

The Calendar is yours for just 6 cents in stamps.

Worth more than that in anybody's art collection.

We offer it as a token of the excellence of

Pabst Malt Extract
The Best Tonic

and you will find our Calendar of Old Japan worthy of the name and fame of its maker.

The "Best" Tonic is good to give and good to take—a nerve builder and blood maker—has no equal where one needs a building up to health.

Send three 2-cent stamps, and you will receive the prettiest and most decorative art calendar of the year.

Address
PABST EXTRACT DEPARTMENT
MILWAUKEE, WIS.

Pabst Extract "American Girl" Calendar for 1912. It measures seven inches by thirty-six inches. The calendar is free but they need a dime to cover the cost of packing and mailing. $8-$12

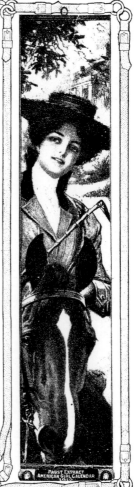

Pabst Extract American Girl Calendar 1912

The Pabst Extract American Girl Calendar for 1912 is an art creation worthy of more than passing notice.

The subtle charm of outdoor life, the captivating beauty of the typical American girl and the artist's masterful portrayal of man's best friend—the horse—combine to make a picture that will instantly appeal to every lover of the artistic and beautiful.

In panel form, seven inches wide and thirty-six inches long and printed in twelve delicately blended colors, this Pabst Extract American Girl Calendar will harmonize well with the furnishings of any room, home, den or office.

No advertising matter whatever, not even the title nor the months, are printed on the front.

Scores of calendars, far less artistic, are sold every year at 75c to $2.00 each, but *we send you this calendar free*, hoping it will serve to remind you that

Pabst Extract
The "Best" Tonic

strengthens the weak and builds up the overworked—relieves insomnia and conquers dyspepsia—helps the anaemic and turns nerve exhaustion into active, healthy vim—encourages listless convalescence to rapid recovery—assists nursing mothers and reinvigorates old age.

The U. S. Government specifically classifies Pabst Extract as an article of medicine — not an alcoholic beverage

ORDER A DOZEN FROM YOUR DRUGGIST

Insist Upon It Being Pabst

This Calendar is Free

All we ask is that you send us ten cents, stamp or coin, to cover cost of packing and mailing. The demand for these beautiful calendars will be great, so write at once if you wish one.

PABST EXTRACT CO. Dept. 16 Milwaukee, Wis.

"Pompeian Beauty" Art Calendar for 1913. On this one you won't find any advertising on the front of the print. It measures eight inches by thirty-two inches. Two samples and print could be had for ten cents. $15-$20

Surprise Them
When Doorbell Rings

How often has this been your experience? It is evening. You are not expecting callers. You are tired and you show it. Suddenly the doorbell rings!

"Callers!" you exclaim to your husband, "and I look like a fright." But there's a way out. Surprise your friends, as have many women who know what Pompeian will do. Slip into your bedroom. Take a one-minute "dry massage" with Pompeian. (By "dry massage" we mean with no moisture added, for now you want the cream to work out quickly. Into the skin the cream goes; in a moment out it comes, and—)

Presto! You are transformed. The tired lines in your face are subdued. The invigorating Pompeian massage has relaxed your tired muscles and refreshed you marvelously. Delightful, natural color has taken the place of your sallow or pale, wan look. The Pompeian massage has brought the rosy blood to your cheeks. Now go out to surprise your friends, for you look ten years younger.

"Why, my dear, how well you look!" exclaims one of the callers. You are pleased. Your husband smiles his proud approval. And, best of all, you both know—and everybody knows—that it is your own honest complexion and not a make-believe, rouge effect. (Rouge and like methods deceive the user only.)

Nothing is left on the face after a Pompeian massage but a clear, fresh, youthful glow. Use Pompeian Massage Cream and have a complexion that is genuinely admired. Try the above plan and surprise your friends. Clip coupon for trial jar and Art Calendar.

Could You Pass This Hard Test?

Applicant: T. F. Miller, Age 31.	Per Cent
Disqualified	
Appearance	75
Character	100
Experience	90
Health	85
Aggressiveness	90
Tact	85

More and more do appearances count. A keen employer reasons thus:

"I can't afford to employ a representative of this house if his looks are going to discount all his other good points. He must be a clean-cut fellow, the kind people like to deal with.

"Nor do I want a man about me who isn't of the clean-cut type. Any other kind gets on my nerves and decreases my own efficiency."

Yes, the man with the clear, clean, healthy skin more easily gets the right position and the right salary. Only a few concerns, as yet, select their salaried men as scientifically as the above efficiency chart shows. But—those points pass through the mind of almost every keen employer.

Appearance is often the first test applied. The sluggish blood that comes from indoor life; the grime of factories; the soot of cities and

Send Now for Art Calendar

In four years the annual "Pompeian Beauty" Art Calendars have become most popular of all.

The 1913 "Pompeian Beauty" (now ready) is 32 by 8 inches. No advertising on the front. Reproduced in exquisite colors, dark green, gold and pink. The picture here, of course, can give only a faint idea of its beauty and richness. Art Calendar and Trial Jar both sent for 10c (stamps or coin, but please send a 10-cent piece if convenient). Please clip coupon now.

"Don't envy a good complexion; use Pompeian and have one."

IMPORTANT—You can't be too careful what you put on your face. Stick to a safe standard massage cream. Do you realize why a cheaply-made imitation or substitute is offered? Because it costs the dealer less and he makes more —at your expense. Get the original and standard massage cream. Get Pompeian. 50,000 dealers sell it, 50c, 75c and $1.

(Continued from 2nd column)

the dust of travel all work against a man's having a clear, clean, healthy skin. Pompeian Massage Cream does cleanse, improve and invigorate the skin marvelously. It rubs in easily out. Nothing is left on the face but an athletic glow, and, in time, a wonderfully clear, healthy, wholesome skin. It is easy to be a "clean-cut" man if Pompeian is used faithfully. Clip coupon for trial jar and Art Calendar.

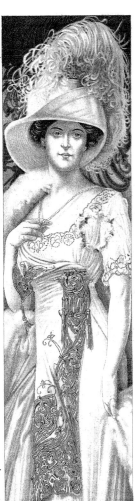

POMPEIAN
MASSAGE CREAM

Sold by 50,000 dealers

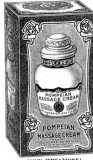

50c, 75c and $1.

SHUN IMITATIONS!

Clip Coupon Now
For Trial Jar and Art Calendar.

Cut off, sign and send

The Pompeian Mfg. Co., 69 Prospect St., Cleveland, O.

Gentlemen—Enclosed find 10c (stamps or coin) for a trial jar of Pompeian and a 1913 "Pompeian Beauty" Art Calendar.

Name ..

Address ..

City State

Both sent for 10 cents (coin or stamps, but please send 10-cent piece if convenient, for stamps get damaged by sticking).

THE POMPEIAN MFG. CO., 69 Prospect St., Cleveland, O.

Pompeian Art Panel for 1918 by Forbes. It measures seven and a quarter inches by twenty-eight inches and shows the beautiful, young Mary Pickford. Panel and samples for only ten cents. Advertisement in McCalls magazine for October, 1917. **$14-$18**

Don't Envy A Good Complexion

Beautify a sallow skin; get the good, red blood coursing through your cheeks by the famous Pompeian method.

A pinch of Pompeian MASSAGE Cream rubbed in, then out again—that's all. But what a difference it makes! Youth stays in your face. Don't envy a good complexion; use Pompeian and have one.

Jars: 50c, 75, and $1, at the stores

POMPEIAN

Is anybody in your family troubled with Dandruff? If so, don't let the matter be neglected, as Dandruff often causes the hair to fall out.

Our new product, Pompeian HAIR Massage, has already won thousands of friends all over the country because it has stopped their Dandruff. It is a liquid (not a cream) and is not oily or sticky. Delightful to use. 50c and $1 bottles, at the stores. Both of the above products are guaranteed by the makers of the famous Pompeian NIGHT Cream.

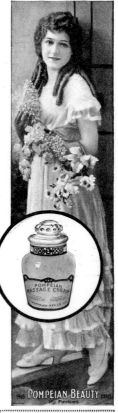

Mary Pickford Art Panel

(No advertising on front)

For a trial jar of Pompeian MASSAGE Cream, and the beautifully colored new 1918 Art Panel of adorable Mary Pickford, (size 7¼ by 28 inches, value 50c) send only 10c. Please clip the coupon.

(Stamps accepted, dime preferred)

The Pompeian Mfg. Co., 2009 Superior Ave., Cleveland, Ohio

Gentlemen: I enclose 10c for a 1918 Mary Pickford Art Panel and a trial jar of Pompeian MASSAGE Cream.

Name

Address

City State

Pompeian Beauty Art Panel entitled " Liberty Girl" for 1919. Samples and Art Panel for two dimes. $14-$18

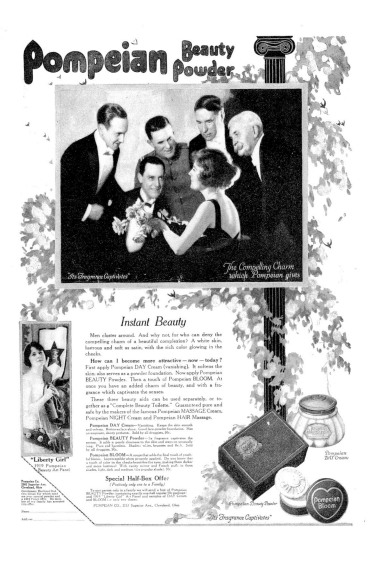

Pompeian Art Panel entitled "Sweetest Story Ever Told" for 1920. It measures eight inches by twenty-eight inches. Art Panel and samples sent for only a dime. Advertised in The Ladies' Home Journal for October, 1919. $14-$18

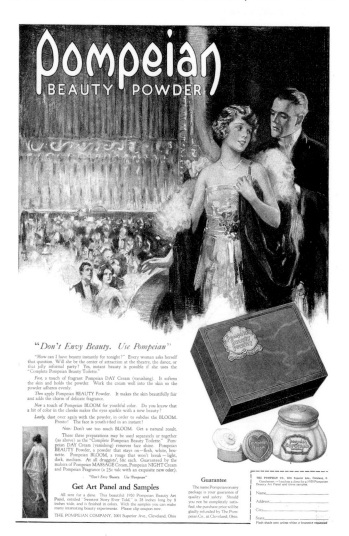

Pompeian Art Panel entitled "Absence Can Not Hearts Divide." It measures seven and a quarter inches by twenty-eight inches, and would be sent for ten cents along with samples. Advertised in The Ladies' Home Journal for September, 1921. $14-$18

Pompeian Beauty powder

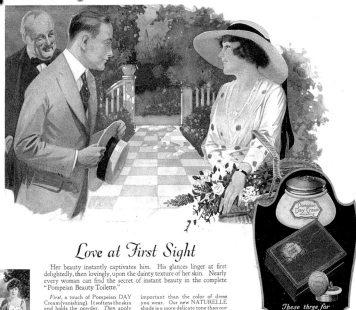

Love at First Sight

Her beauty instantly captivates him. His glances linger at first delightedly, then lovingly, upon the dainty texture of her skin. Nearly every woman can find the secret of instant beauty in the complete "Pompeian Beauty Toilette."

First, a touch of Pompeian DAY Cream (vanishing). It softens the skin and holds the powder. *Then* apply Pompeian BEAUTY Powder. It makes the skin beautifully fair and adds the charm of fragrance. *Now* a touch of Pompeian BLOOM for youthful color. Do you know that a bit of color in the cheeks makes the eyes sparkle? Presto! The face is beautified and youth-i-fied in an instant! (Above 3 articles may be used separately or together. At all druggists', 60c each.)

TRY NEW POWDER SHADES. The correct powder shade is more important than the color of dress you wear. Our new NATURELLE shade is a more delicate tone than our Flesh shade, and blends exquisitely with a medium complexion. Our new RACHEL shade is a rich cream tone for brunettes. See offer on coupon.

Pompeian BEAUTY Powder—naturelle, rachel, flesh, white. Pompeian BLOOM—light, dark, medium. Pompeian MASSAGE Cream (60c), for oily skins; Pompeian NIGHT Cream (50c), for dry skins; Pompeian FRAGRANCE (30c), a talcum with a real perfume odor.

These three for Instant Beauty

"Don't Envy Beauty— Use Pompeian"

GUARANTEE
The name Pompeian on any package is your guarantee of quality and safety. Should you not be completely satisfied, the purchase price will be gladly refunded by The Pompeian Co., at Cleveland, Ohio.

TEAR OFF NOW
To mail or for Pompeian shopping-hint in purse

THE POMPEIAN COMPANY
2001 Payne Avenue, Cleveland, Ohio
Gentlemen: I enclose a dime for the 1921 Marguerite Clark Panel. Also please send the 5 samples.

Name _____

Address _____

City _____

State _____

Naturelle shade powder sent unless you write number below.

Marguerite Clark Art Panel — 5 Samples Sent With It

Miss Clark posed especially for this 1921 Pompeian Beauty Art Panel entitled, "Absence Can Not Hearts Divide." The rare beauty and charm of Miss Clark are revealed in dainty colors. Size, 28 x 7¼ inches. Price, 10c. Samples of Pompeian Day Cream, Powder and Bloom, Night Cream and Fragrance (a talcum powder) sent with the Art Panel. With these samples you can make many interesting beauty experiments. Please tear off coupon now.

THE POMPEIAN COMPANY, 2001 Payne Avenue, Cleveland, Ohio
Also Made in Canada

"Absence Can Not Hearts Divide"

Pompeian Art Panel, "Beauty Gained is Love Retained" for 1925. It measures seven and a half inches by twenty-eight inches. Panel and four samples for ten cents. Advertised in The Ladies' Home Journal for December, 1924.
$7-$10

Your skin demands
the constant attention of these creams

By MME. JEANNETTE

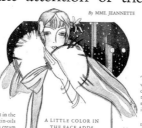

A DRY skin
chaps easily—it needs much Night Cream

Women with the type of skin classified as dry have to be on the alert all the time to preserve the natural beauty of their delicate complexions—and to bring out the charm they have!

The dry skin requires continual nourishment in the form of healing and feeding oils. These fine skin-oils are found in Pompeian Night Cream, and this cream offers great benefits to the dry skin

The care of skin is not a matter of using Pompeian Night Cream for a few days and nights—and then finding that your skin has become radiantly beautiful! Pompeian Night Cream is a corrective of the abuses you may have subjected your skin to for years, and its excellence is found in its steady, certain power to improve your complexion.

As a treatment: Once a day this skin requires special attention with cream. The skin should be thoroughly covered, then gently wiped off. Next, small quantities of the cream should be applied with the tips of the fingers, working in little circular movements. Be very careful not to press the fingers down hard, for the dry type of skin must be treated very delicately. After some of the cream is absorbed, tap the skin gently with finger-tips till there is only the slightest trace of the cream. Bathe in cold water or rub with a piece of ice and rest for fifteen minutes before going out or putting on powder.

As a cleanser: Pompeian Night Cream should always be used to cleanse a dry skin. Too much water will make this skin harsh. Apply the cream generously and wipe off gently—and repeat the cream-application as many times as the skin shows superfluous soil or grime.

As a powder base: After cleansing the skin add a slight quantity of Pompeian Night Cream, pat into the skin well and wipe off with soft cloth or tissue. This forms an ideal powder base for a dry skin.

Pompeian Night Cream, 60c the jar (slightly higher in Canada).

Pompeian Night Cream

A LITTLE COLOR IN THE FACE ADDS BEAUTY

The use of a pure, harmless rouge beautifies the skin, and gives it the same sort of protection as a good powder. Pompeian Bloom used with Pompeian Beauty Powder gives a natural color that cannot be detected when used correctly.

No woman, today, wants to be noticeably "made up," and the application of your powder and rouge should be given the same care you accord to dressing your hair. Powder and rouge must be applied as a part of your entire toilette, and must be blended carefully and with discrimination.

Mme. Jeannette

Spécialiste en Beauté

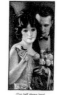

(Top half shown here)

GET 1925 POMPEIAN PANEL AND FOUR SAMPLES

This new 1925 Pompeian Art Panel, "Beauty Gained is Love Retained," size 28 x 7½. Done in color by a famous artist; worth 50c. We send it with samples of Pompeian Beauty Powder, Bloom, Day Cream and Night Cream for 10c. With these samples you can make many interesting beauty experiments. Use the coupon now.

Pompeian Laboratories, 2001 Payne Ave., Cleveland, Ohio

Gentlemen: I enclose 10c (dime preferred) for the new 1925 Pompeian Art Panel, "Beauty Gained is Love Retained," and the four samples named in offer.

Name

Address

City _____ State

Shade of powder wanted?

© 1924. The Pompeian C——

An OILY skin
may become sluggish— it needs two creams

During the severe weather of winter every woman must pay very special attention to the care of her skin if she wants to have it lovely to look at during the social season. An oily skin may have its drawbacks, but it also has its advantages.

One of its greatest advantages is its ability to keep young-looking. Women with oily skin retain a certain fresh youthfulness in the texture of skin for years—*if they take care of it.*

The very fact of excess oil is an asset to the woman who is particular about her toilette. Yes, it *does* require a little more of your time, for its very activity makes it demand constant attention. The natural oil, if controlled, keeps the skin soft and pliable, and less subject to lines and aging wrinkles. But an oily skin must guard against enlarged pores and a tendency to shine. Cream-cleansing and cream-protection are both essential to this skin. This is generally a healthy skin and can stand frequent treatments.

Pompeian Night Cream has oils in it that dissolve and carry off the excess oil of the skin, with the removing of the superfluous cream. Pompeian Night Cream thus cleanses an oily skin in the most efficient and scientific manner.

Pompeian Day Cream is invaluable for the oily skin, having a slightly astringent quality that makes it especially good for the relaxed pores, gently reducing them to a more normal condition.

Women with an oily skin should always use Pompeian Day Cream as a powder base. It removes oil, and forms a protective base for your powder.

Pompeian Day Cream is a vanishing cream, and should be applied in very small quantities, going over each little space of skin till the entire surface is covered with a delicate film. Thus it forms a protection to the skin, and an adherent foundation for your powder.

Pompeian Day Cream, 60c the jar (slightly higher in Canada).

Pompeian Day Cream

Pompeian Art Panel for 1926 by Gene Pressler. It measures seven inches by twenty-seven inches entitled, "Moments That Will Treasured Be, in the Mint of Memory." Two samples and the Art Panel were sent for only twenty cents. Advertised in McCall's magazine for October, 1925.

$10-$15

Don't Envy Beauty—Use Pompeian

What is your title for this picture?

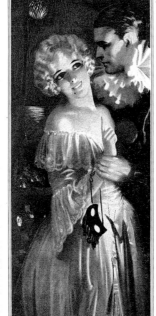

HER whole evening had been a success. Everyone had wanted to dance with her —and it was wonderful to hear so many flattering things.

Perhaps all those dull times she *used* to know were gone forever! It was amazing to find out how completely a girl could change her appearance by "knowing what to do." She had Madame Jeannette to thank—for it certainly made a difference, now that she knew how to care for her skin.

She had learned from Madame Jeannette how to select the proper shade of Pompeian Beauty Powder and to apply it correctly for youthful beauty.

Pompeian Beauty Powder is used the world over by women who find that it meets every requirement of beauty, protection, and purity.

It has an exceptionally adhesive quality, which makes the powder stay on an unusually long time. It is made of the very finest ingredients.

Mme. Jeannette's Beauty Treatment

First, a bit of Pompeian Day Cream to make your powder cling and prevent "shine."

Next, apply Pompeian Beauty Powder to all exposed portions of the face, neck and shoulders. It will give your skin that lovely effect of rose petal softness.

Lastly, a touch of Pompeian Bloom to bring exquisite youthful color.

Shade Chart for selecting your correct tone of Pompeian Beauty Powder:

Medium Skin—The average American woman has this type of skin, and should use the Naturelle shade of Pompeian Beauty Powder.

Olive Skin—This skin generally accompanies dark hair and eyes. It is rich in tone and should use Rachel shade of Pompeian Beauty Powder.

Pink Skin—This is the youthful, rose-tinted skin, and should use the Flesh shade of Pompeian Beauty Powder. This type of skin is usually found with light hair, or red hair.

White Skin—If your skin is quite without color, use White powder. Only the very white skin should use white powder in the daytime.

Purity and satisfaction guaranteed.

$1,000.00 for best titles

PLEASE help us get a title for this beautiful picture—the 1926 Pompeian Beauty Panel. A few moments' thought may bring you cash for your cleverness.

Who will win this prize?

You—if you are the one who can best imagine yourself in this enchanting scene—a flower-scented night with a full moon splashing its silver through the palm trees and over the little dancing waves at Palm Beach, Miami— or is it California? Shut your eyes and think how wonderful it would be—you and the-dearest-one-in-the-world. That odor of flowers —are they orange blossoms? And is this fancy dress ball just planned for two hearts to find each other?

How would *you* describe this scene in a few words? Write down the titles that come to you; then send in the best one.

CASH PRIZES. 1st, $500; 2nd, $250; 3rd, $150; and 2 prizes of $50 each.

SUGGESTIONS. These titles may set your mind working—Beauty's Reward; Love's Hour; One or None?; "I Love You, Dearest"; Beneath the Palms; Beauty Wins.

RULES

1. Only one title for one person.
2. Ten words or less for the title.
3. Write title on one sheet of paper. Below title write only your name and full address plainly. Mail to the Pompeian Laboratories, Cleveland, O.
4. Coupon and coin for panel can be sent along with your title.
5. Contest closes November 30, 1925, but get your title in early.
6. In the event of a tie for any prize offered, a prize identical with that tied for will be awarded to each tying contestant.
7. Prizes paid December 15, 1925. Winners announced January 9, 1926, in Saturday Evening Post.

Note. If you plan to get panel anyhow, you can send for it first and study it in full size and colors. Then send in your title. However, no one is required to get a panel to enter contest.

GET 1926 PANEL
and Samples

This is the most beautiful and expensive panel we have ever offered. Executed by the famous colorist, Gene Pressler. Size 27 x 7 inches. Art store value 75c to $1. Sent for two dimes along with valuable samples of Pompeian Bloom (for youthful color); Pompeian Beauty Powder; Pompeian Day Cream (powder base); and Pompeian Night Cream (skin nourishing). Tear off the coupon now, enclose 2 dimes and send today.

Save and study this offer

Pompeian Beauty Powder 60c

Pompeian Day Cream 60c

Pompeian Night Cream 60c

Pompeian Bloom 60c

Pompeian
Beauty Powder

TEAR OFF, SIGN AND SEND

The Pompeian Laboratories
3423 Payne Ave., Cleveland, Ohio
I enclose 2 dimes (20c) for 1926 Pompeian Beauty Panel and valuable samples.

Name_____

Address_____

City_____ State_____

Shade of powder wanted?_____

Pompeian Art Panel entitled "The Bride" by Rolf Armstrong. It measures seven inches by twenty-seven inches and could be had for ten cents, along with two samples. Advertised in The Ladies' Home Journal for October, 1926. $15-$18

Exquisite Natural Coloring

comes from using the right shade of Pompeian Bloom

By MME. JEANNETTE CORDET
Famous cosmetician, retained by The Pompeian Laboratories as a consultant to give authentic advice regarding the care of the skin and the proper use of beauty preparations.

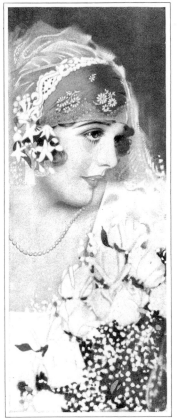

J RECENTLY heard one girl say to another: "You need no rouge, my dear! What lovely natural coloring!" But the truth was this: she had found a rouge that gave her cheeks the exquisite natural coloring of a girl in her 'teens. That rouge is Pompeian Bloom.

Rouge to match the various skin tones must be a blend of several colors. Pompeian Bloom comes in five scientifically blended shades—scientifically blended because Pompeian chemists know that complexions are not composed of single colors, but a blend of many.

From the shade chart below you can easily select your particular shade of Pompeian Bloom. Listed there is your type of complexion together with the shade of Pompeian Bloom that matches it perfectly.

SHADE CHART *for selecting your shade of Pompeian Bloom*

Medium Skin: The average American woman has the medium skin-tone—pleasantly warm in tone with a faint suggestion of old ivory or sun-kissed russet. The *Medium* tone of Pompeian Bloom suits this skin. If with a medium skin you are slightly tanned, you may find the *Orange* tint more becoming. And sometimes women with medium skin who have very dark hair get a brilliant result with the *Oriental* tint.

Olive Skin: Women with the true olive skin are generally dark of skin and hair—and require the *Dark* tone of Pompeian Bloom. If you wish to accent the brilliancy of your complexion, the *Oriental* tint will accomplish it.

Pink Skin: This is the youthful skin, most often found in blondes or red-haired women, and should use the *Oriental* shade.

White Skin: The pure white skin is rare, but if you have this rare skin you must use the *Light* tone of Bloom.

Special Note: Remember that an unusual coloring of hair and eyes sometimes demands a different selection of Bloomtone than given above. If in doubt, write a description

When the gay sports of autumn call the smart set out-of-doors, the charming women add just a bit more Bloom to their coloring as a foil for their rich furs and snug hats.

Get New Panel and Samples

The picture shown here represents the lovely new 1927 Pompeian Art Panel entitled "The Bride," which we offer our friends for only 10c. Painted by the famous artist, Rolf Armstrong, and faithfully reproduced in ten color printings. Actual size 27 x 7 inches. Its art store value would easily be 75c to $1.00.

With the Art Panel (and at no extra charge) Madame Jeannette Cordet will send you generous samples of Pompeian Bloom and Pompeian Beauty Powder. Specify on the coupon the shade of rouge you wish. Madame Jeannette's booklet of beauty hints and secrets will also be sent to you with the samples and the Art Panel.

Clip the coupon, enclose a dime and send today.

Use the coupon now!

of your skin, hair and eyes to me for special advice.

If you really want your color to look exquisitely natural, begin using Pompeian Bloom. 60c at all toilette counters. (Slightly higher in Canada.) Purity and satisfaction guaranteed.

I also suggest that you use Pompeian Day Cream as a foundation for your Pompeian Beauty Powder and Bloom.

Jeannette Cordet
Specialiste en Beauté

Pompeian Art Panel, "Cinderella" for 1930 by Clement Donshea. It measures seven and a half inches by twenty-eight and a half inches. Two samples and the print were sent for only ten cents. Advertised in the Ladies' Home Journal, November, 1930. $8-$12

Cinderella
1930

Valerie's breath came in short, excited gasps...she wondered if the couples dancing past her could hear the pounding of her heart.

She had never dreamed it could come true! Ever since schooldays she had secretly adored Hal...had cheered him through countless football triumphs.

But Valerie herself had none of the glamour and beauty to awaken a like response. Sallow of skin, nondescript as to hair and eyebrows, even her clear blue eyes were lost in the monotone of her skin and coloring.

But tonight...everything was different! Hal had cut in on every dance...his eyes followed her wherever she went—and now the real moment had come! He was telling her that he loved her.

● **Valerie had learned the secret**

The ugly little duckling who had envied the fresh loveliness of other girls was tonight the most exquisite of them all. The sallow skin had given way to a fresh radiance of an opalescent brilliance...her eyes were aquamarine pools of liquid light—and these had brought new amber glints to her hair.

Valerie had discovered that the clever placing of Pompeian Bloom (a vibrant, pulsing color of Medium tint) and a smooth, invisible dusting of Pompeian Beauty Powder (in the mysterious Nude tone) would give her that "tanned-blonde" effect which Hal found so enchanting.

● **it's only natural**

Millions of women of every type of coloring prefer Pompeian Beauty Powder for perfectly natural reasons. It spreads evenly and smoothly...it doesn't cake...it clings for hours.

After years of experimenting on living models, Pompeian has produced five perfect colors...each a blend of countless shades, as subtly wedded as are the shades with which Nature colors the skin itself. One of these is a tint which will flow smoothly into the tones of your skin.

● **the bloom on the skin**

Pompeian Bloom is vibrant, shaded coloring which has none of the unnatural solidity of a single tone. Each of the five tints is a blend of many, many living shades and the effect is one of a glowing color, pulsing below the skin.

Pompeian Bloom comes off on the puff without crumbling and spreads creamily on the skin. It clings loyally and lastingly.

● **the price is important, too**

An alarming amount can be spent on toiletries if one is not a knowing shopper. Before you realize it, your toilette expenses can have cut into your dress allowance. And how unnecessarily! Because Pompeian Powder has such vast, world-wide popularity, it is possible to produce the purest, finest quality for the amazingly low sum of 60c. Pompeian Bloom is another matchless value. In a dainty metal case, with mirror and long-life puff, it is 60c.

THE POMPEIAN COMPANY, INC., New York, N. Y., Elmira, N. Y. and Toronto, Canada.—(*Sales Offices:* Harold F. Ritchie & Co., Inc., Madison Ave. at 34th St., New York and 10 McCaul St., Toronto, Can.)

● **do you know your type?**

Your most potent charms? How to enhance them? Mme. Jeanette de Cordet —skilled specialist in feminine beauty —describes and prescribes for 24 types in her elaborate booklet on making the most of your looks. The coupon below tells how to secure it.

Send for your copy of the new Pompeian Art Panel

The illustration in this advertisement is by Clement Donshea, master painter of beautiful women. It has been expensively reproduced—in full color—in the new Pompeian Art Panel, size 7½ x 28¼, suitable for framing. Its artistic and decorative value will appeal to you. Send for your copy.

Enclose 10c. You'll receive the Art Panel—Mme. de Cordet's booklet—and samples of two other toilet necessities—Pompeian Day Cream and Night Cream.

● Be sure to PRINT name and address

Mme. Jeanette de Cordet,
Dept. 11-11, The Pompeian Laboratories,
Elmira, N. Y.

I enclose 10c (coin) for the Art Panel and a copy of booklet "Your Type of Beauty." Include the samples of Pompeian Day Cream and Night Cream.

Name...................................

Street Address...................................

City.................... State....................
(In Canada, address 10 McCaul Street, Toronto)

POMPEIAN
BEAUTY POWDER AND BLOOM

The Calendar for 1909. "In Grandmother's Garden" by Charles C. Curran. It measures nine and a quarter inches by thirty-four inches with the calendar at the bottom of the print. Advertised in The Youth's Companion, November 5, 1908 "to all who pay their subscription for 1909." $7-$10

FROM NOVEMBER 5, 1908 THE YOUTH'S COMPANION

THE MIND OF THE WORLD